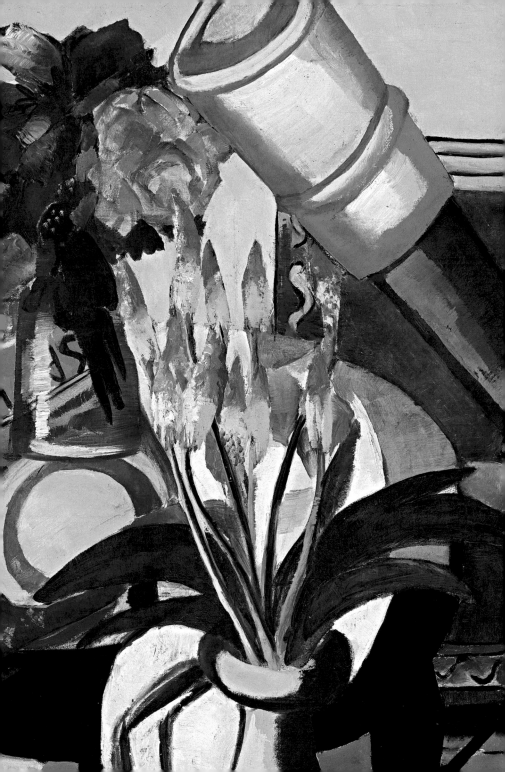

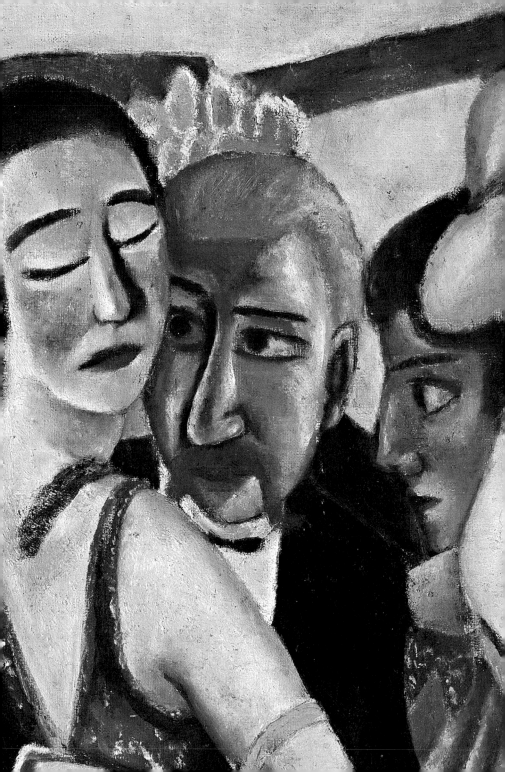

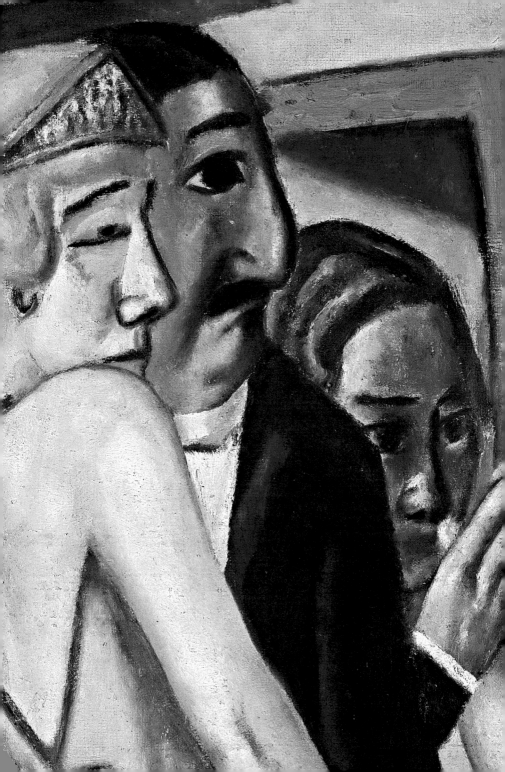

MAX
BECKMANN

by
Christiane Zeiller

with an essay by
Bernhard Maaz

HIRMER

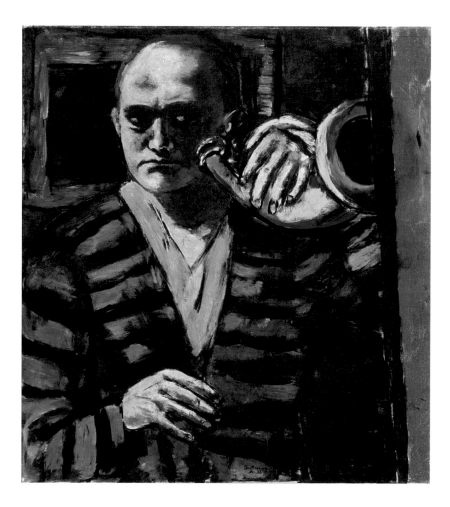

MAX BECKMANN
Self-Portrait with Horn, 1938, oil on canvas
Ronald S. Lauder, permanent loan to the Neue Galerie, New York

CONTENTS

1 *Acacia in Bloom*, 1925, oil on canvas
Private collection northern Germany, Courtesy Villa Grisebach

'ART IS BLOODY DIFFICULT'[1] BECKMANN'S STRUGGLE FOR A CONTEMPORARY ART

Christiane Zeiller

[...] like when a city is so tied to a river that it seems to flow with it, – like trees that, when they are bare, become so afraid that they seem to freeze, and when they bloom it is like a storm of love, that is what interests us. This vitality behind the notions, which breaks out from them only for those who have eyes to see, the relations that we cannot see with the 'naked' eye, that is what <u>our</u> painters should paint. And that is what Beckmann paints.[2]

Heinrich Simon

Heinrich Simon was the editor of the arts section of the *Frankfurter Zeitung* when he published the text cited above. He had met Max Beckmann soon after the latter's return from the First World War (3), when the painter, who had previously lived in Berlin, came to Frankfurt in the autumn of 1915. Beckmann had suffered a nervous breakdown caused by the psycho-logical shock suffered during his service as a volunteer paramedic in East Prussia, Flanders and most recently Strasbourg.

The leading members of the Frankfurt cultural scene met regularly at the home of Heinrich Simon and his wife, among them Georg Swarzenski,

2 *Winter Scene*, 1930, oil on canvas
Van Abbemuseum Collection, Eindhoven, Netherlands

Wilhelm Hausenstein, Rudolf Binding and Benno Reifenberg. As an en-
thusiastic journalist and publisher, Simon owned and valued Beckmann's
works. In the Beckmann volume published in the series *Junge Kunst* (Young
Art) in 1930, he analysed the painter's style convincingly and concisely,
concluding that Beckmann had succeeded in 'finding, inventing, a pictor-
ial space corresponding to the times'.[3]
With the question of what was contemporary and topical in Beckmann's
art, Simon rekindled a debate that had already been heatedly discussed
by critics and fellow artists at the beginning of his early, meteoric career

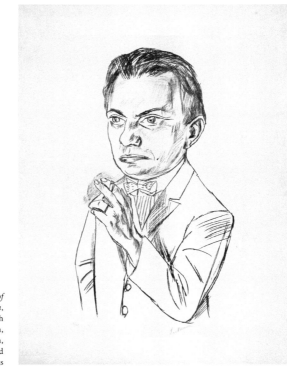

3 *Portait of
Dr. Heinrich Simon*,
1922, lithograph
Städel Museum,
Frankfurt am Main,
Collection of Prints and
Drawings

before the First World War. The issue was Beckmann's relationship with modernism – his great talent was generally accepted as undisputed – and whether his art should be labelled as modern, contemporary, Romantic or even old-fashioned, as well as how it stood in relation to the self-proclaimed avant-garde in Germany. In light of the revolutionary new developments in the visual language of the period, Beckmann's downright stubborn traditionalism irritated many.

He had always been and was to remain a solitary figure, refusing to allow himself to be classified as a member of artistic groups and tendencies. To this day, the stylistic category of Expressionism is often employed for the art he created after the First World War, although it does not do justice to it.

His legendary theoretical dispute with Franz Marc, carried out in the journal *Pan* in 1912, reveals insights into his remarkably differentiated

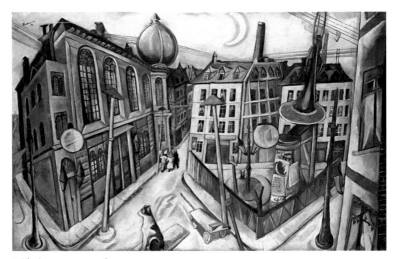

4 *The Synagogue,* 1919, oil on canvas
Städel Museum, Frankfurt am Main

self-perception, his relationship to nature and his assessment of Paul
Cézanne – whom he fervently admired – as well as his contribution to
modernism. Beckmann had added a title to his reply to Marc's remarks
that consciously paraphrased Nietzsche, 'Thoughts on Modern and Un-
modern Art'. In it Beckmann asserted that art should have a connection
with the present. 'Objectivity', the real world and the sensuality of objects
were to be reflected by the artist. Franz Marc, for his part, demanded from
artists of the 'new painting' an awareness of the inner spirit and a mysti-
cally transfigured rejection of the world that surrounds us that was con-
trary to Beckmann's conception. Both of them looked toward France. The
Parisian avant-garde had been fundamental for Marc since his visit to the
French capital in 1907. Beckmann invoked the monumental painters of
the nineteenth century instead, such as Théodore Géricault and Eugène
Delacroix. Similarly, among his fellow painters he permitted only the Old
Masters to serve as a point of reference for himself. So as not to run the risk
of 'growing rigid' in a 'certain style', he wrote, he had studied the Old Mas-
ters and their view of nature intensively.[4] He regarded Gabriel Mäleßkircher,
Matthias Grünewald, Pieter Brueghel the Elder, Jacopo Tintoretto, Peter
Paul Rubens and Rembrandt as his true teachers. Painting that had

depth, figures that were sculpturally arranged, the penetration of the visible... these were the maxims to which Beckmann considered himself duty-bound.

By contrast, in this early *Pan* debate he polemically judged contemporary developments, such as the Cubism of Pablo Picasso, as flat, decorative handicraft, disparaging his works as 'little Picasso chequerboards'.[5]

HONEST OBJECTIVITY

'Being a child of one's time. Naturalism against one's own ego. Objectivity the inner face'.[6] This is how, five years later, Beckmann summarised the programmatic demands on his art, noting them in the preface to the catalogue of an exhibition at the gallery of the art dealer and publisher J. B. Neumann. There he again stated his rejection of abstraction, which he considered too distant from nature. He held on insistently to the representational and even linked this with a commitment to truth – a concept that testifies to his fundamental proximity to Romanticism.

When we think of Beckmann's painting today, we first have the works from the successful Frankfurt years in mind. Nowhere did the painter live and work longer than here, and his international success – in the United States too – first began in Frankfurt. This was the period between his return from the war and his persecution by the National Socialists, who dismissed him from the Städelschule art school in 1933, subsequently defamed his art as 'degenerate' and removed it from German museums. During this period of almost two decades, he fundamentally renewed his pictorial language after the torpor brought on by his wartime experiences.

This new language had already been prepared and laid out in his drawings. In feverish haste, Beckmann had captured on paper the exploding world of the trenches, military hospitals and morgues during the war years, testimonies to the suffering and dying around him. A masterpiece such as *The Night* from 1918/19 (5), Beckmann's cruelly staged chamber play of a brutal crime against a family, was still characterised by the gloomy, pale palette of the immediate post-war years and the somewhat brittle, angular lines reminiscent of late Gothic carving. Contrary to what the subject might suggest, it was important to the painter that the beauty of the picture be recognised, its craftsmanship, as it were, and to show

5 *The Night*, 1918/19
Oil on canvas
Kunstsammlung
Nordrhein-Westfalen,
Düsseldorf

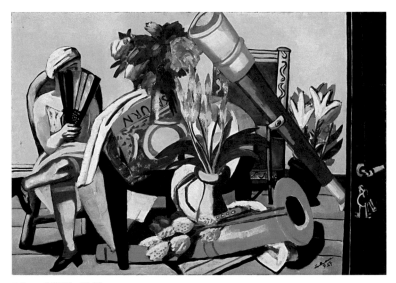

6 *Large Still Life with Telescope*, 1927
Oil on canvas, Pinakothek der Moderne, Munich

what he was capable of. He remarked self-ironically to Reinhard Piper that he certainly did not want to be considered a specialist in atrocities. At the same time, he emphasised his striving for a clear, definite form, for 'honest representationalism' – here, too, in an implicit demarcation from abstract painting.

NEW SELF-CONFIDENCE

In the early 1920s Beckmann's colour palette brightened hesitantly but increasingly, and sumptuous paintings celebrating life emerged. The *Large Still Life with Telescope* from 1927 (6) is a prime example of this new era: an opulent credence table and behind it a silver, blue-covered throne await the arrival of a master, of a magician – of the artist himself.

Although the palette becomes lighter and the lush colours gleam clearly and exquisitely, black remains Beckmann's trademark: as a thick outline around his figures; as a grid, beam and obstacle, blocking access to his pictorial spaces. The brushstroke, which was already firmly placed in the

pre-war pictures, becomes even more definite, more decisive, more relent-less. There is nothing vague or floating in Beckmann's pictures, no hints, no suggestions.

By the mid-1920s, the painter had already become a star – even far be-yond the borders of Frankfurt. An important monograph was published in 1924 in which leading art scholars of the time such as Julius Meier-Graefe, Wilhelm Fraenger, Wilhelm Hausenstein and Curt Glaser com-mented on Beckmann's art. In 1926 his first solo exhibition abroad was held at J. B. Neumann's gallery in New York; his painting *The Box* (8) was awarded a prize at the International Exhibition of the Carnegie Institute in Pittsburgh. Subsequently, lucrative contracts with dealers ensured his eco-nomic success.

Beckmann's appointment to the Städelschule art school in 1925 and the teaching position that went with it must have been both an acknowledge-ment and an ordeal for him. 'My form is painting, and I am quite content with it, for I am actually not very talkative by nature, and at most a burning

7 *Large Storm Landscape*, 1932, oil on canvas
Pinakothek der Moderne, Munich

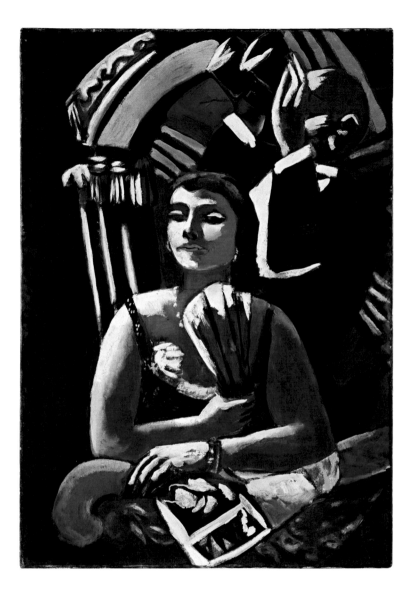

8 *The Box*, 1928, oil on canvas
Staatsgalerie Stuttgart

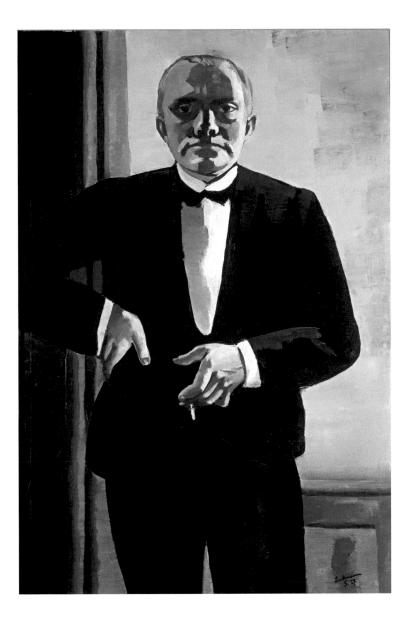

9 *Self-Portrait in Tuxedo*, 1927, oil on canvas
Harvard Museum, Cambridge, MA

interest in a matter can force me to wring something out of myself.'[7] By his own admission, he found talking about painting redundant to the point of ridiculousness. Nevertheless, his surviving talks and lectures remain testimonies of extraordinary value and have not lost their relevance to this day.

His self-confidence, which had recovered and strengthened after the horrific experiences of the war, is reflected in his writings as well as in the self-portraits of this new period. If in the *Self-Portrait with Champagne Glass* from 1919 the painter appears hurried, bent and distorted, virtually clinging to the counter, now, in 1927, he confronts us self-confidently, like the statue of a ruler, in a tuxedo (9). The year before, Beckmann had published his essay *The Artist in the State*, in which he claimed – similar to his self-portrait – that 'the new type of artist is the actual creator of the world.'[8] The attribute of the divine had been bestowed for centuries on masters such as Michelangelo and Raphael; now Beckmann continued this genealogy with a self-confidence bordering on presumption – an attitude that was not always positively received by contemporary critics.

ARTISTIC INVASION

The artistic impetus, the élan from the mid-1920s onwards, went hand-in-hand with Beckmann's private happiness in his second marriage to Mathilde, familiarly known as 'Quappi', the daughter of the prominent painter Friedrich August von Kaulbach (10). He travelled with his young wife to St. Moritz and Garmisch in winter, and in summer to the Riviera and Côte d'Azur or to Baden-Baden, where he observed the refined spa crowd of war profiteers and their entourage at their chic diversions (11). Rustling silk robes, glittering sequins, jewellery, the battle of the sexes to the rhythm of the tango – the painter filled the tight pictorial space in oppressive constriction with what he saw.

10 *Portrait of Quappi in Blue*, 1926
Oil on canvas, Pinakothek der Moderne, Munich

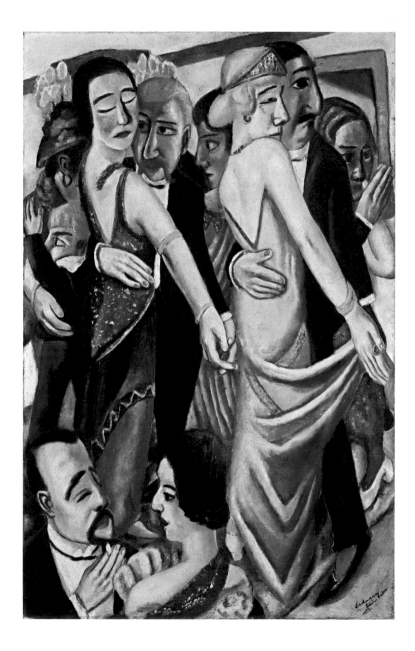

11 *Dance Bar in Baden-Baden*, 1923, oil on canvas
Pinakothek der Moderne, Munich

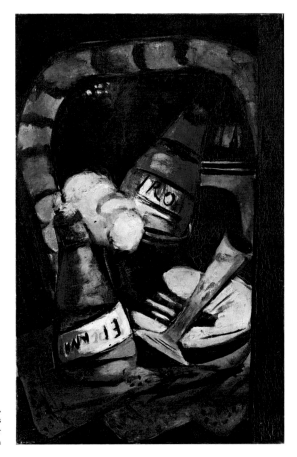

12 *Irroy Still Life,*
1929, oil on canvas
Pinakothek der
Moderne, Munich

Beckmann, who never cultivated the bohemian attitude of other artists, painted his pictures wearing a suit, appreciated champagne, good food and expensive cigars. From 1929 to 1932 he also took up residence and a studio in Paris, with the aim of expanding the sphere of his commercial activities. In his case, one could even speak of a deliberate – but artistic! – intention of invasion (13). When his first one-man exhibition in France was held there in 1931 at the Galerie de la Renaissance, it must have given the painter great satisfaction.

There were few artists of his generation with whom Beckmann competed. Certainly the most important among them throughout his life was Pablo

Picasso, who had achieved success in Paris at an early age. The competition with the great figure painter had begun in the debate with Franz Marc; Beckmann was repeatedly driven to compete with Picasso. Immediately after the First World War, the stylistic confrontation with the Spanish artist becomes apparent. A work such as the *Portrait of Max Reger* of 1917 (14), which, unusually for Beckmann, is painted not from nature but from a photograph, reveals this with its great force of expression and radical simplification of form. Similarly, the proximity to Picasso is obvious in Beckmann's portrait of his first wife Minna Beckmann-Tube (15). Here, as in the contemporaneous drawings, the picture is dominated by powerful, clear lines, the closed form and the modelled body set into the surface. Beckmann carefully noted the extent to which Picasso appeared in exhibitions or art books. He owned a number of catalogues and studies of his work – more than on any other contemporary painter.

HUMAN DRAMAS

When Heinrich Simon saw Beckmann as one of 'our' painters in 1930, he was consciously situating his art in the here and now, despite opinions to the contrary. His painting, asserted Simon, dealt with the human struggle for existence in the most diverse forms, with life, with existence. Monumental works such as the *Scene from the Destruction of Messina* from 1909 (16) and the *Sinking of the Titanic* from 1912 (17) reflect contemporary apocalypses. But Beckmann also painted – like a madman – against the chaos of the world around him in pictures from the life and passion of Christ, depicting colossal human dramas.

For him, religion was on an equal footing with art and science in its importance as 'helper and liberator on the path of humanity [...]. It liberates through form the many ambiguities of life and sometimes lets us look behind the dark curtain that veils the invisible spaces in which we will once be united'.[9] His involvement with religion and God was of a very personal nature – as becomes clear in some of the pages from the late graphic sequence *Apocalypse* (18). Consequently, his art always remains worldly and topical, despite the mythological subject matter. Beckmann challenged God in his works like a wrestler: 'My religion is arrogance before God. Defiance against God. Defiance that he created us in such a way that we

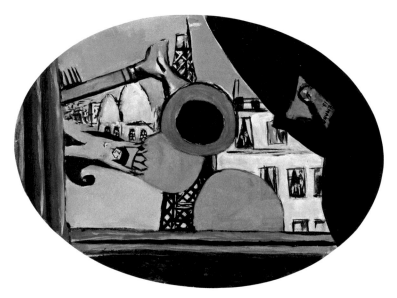

13 *Parisian Dream Colette, Eiffel Tower*, 1931
Oil on canvas, Private collection

cannot love each other. In my paintings I accuse God of everything he has done wrong.'[10]

This statement can only be misunderstood as blasphemous if taken at face value; in reality, it testifies to Beckmann's incessant struggles with his art. He himself, not God or other artists, was his greatest opponent, his challenger to ever new peak performances. This was recognised by others too. The collector and art dealer Günther Franke, who donated one of the most important Beckmann collections in the world to the Bayerische Staatsgemäldesammlungen, wrote in a letter to Beckmann shortly before his death: 'I admire the fact that you work incessantly and always occupy your position anew. How many get tired over the years or repeat themselves.'[11]

The struggle for form, this struggle leaves its mark. Never, even in his happiest, most successful times, does Beckmann become facile; no work, be it a still life or a Mediterranean landscape, is pleasing, is easily appealing. The artist demanded a great deal from the viewer, even from those who admired him. This is reflected in a letter from Georg Hartmann, a Frankfurt

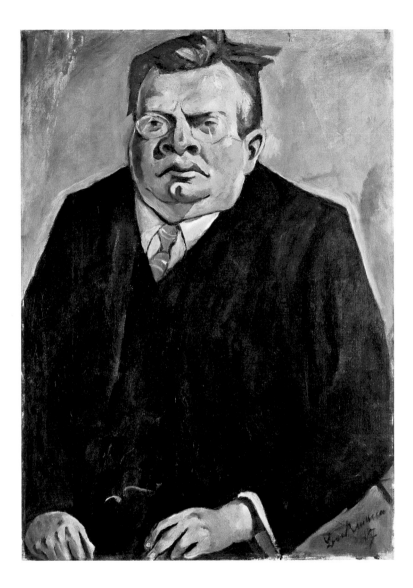

14 *Portrait of Max Reger*, 1917
Oil on canvas, Kunsthaus Zürich

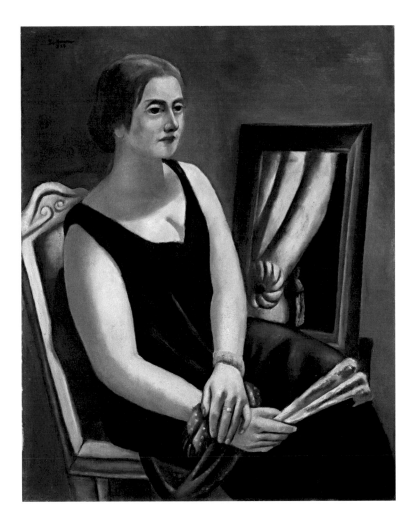

15 *Portrait of Minna Beckmann-Tube*, 1924
Oil on canvas, Pinakothek der Moderne, Munich

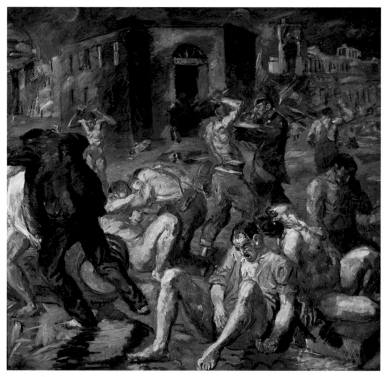

16 *Scene from the Destruction of Messina*, 1909, oil on canvas
Saint Louis Art Museum, bequest of Morton D. May

entrepreneur and owner of the Bauer'sche Schriftgießerei type foundry, who had commissioned drawings for Goethe's *Faust II* (19) from Beckmann. After receiving the first consignment in 1943, he wrote to the painter, at that time in exile in Amsterdam, that he was excited about the works, only to specify immediately afterwards: 'Perhaps "excited" is too general a word in this case, for your pictures did not present themselves as some easy and very pleasant thing. Like any strong creation, like any work of proper artistic density, they resisted.'[12]

This artistic density, the enormous ambition and the constant self-questioning – which some found irritating – reflects Beckmann's struggle. His self-examination is attested to by an impressive number of self-portraits in all genres. We encounter him more than 60 times in paintings, while the self-portraits are numerous in his drawings and

prints. These pictures, like the photographic portraits, show the artist with the typical grim, hard and reticent expression and the searching, self-critically questioning gaze, which is indispensable because, according to Beckmann, 'since we still do not know exactly what this "I" [...] actually is, everything must be done to recognise the "I" ever more thoroughly and deeply'.[13]

WORLD THEATRE

In the 1920s, the world of theatre, the circus, cabaret and carnival also gained importance in Beckmann's oeuvre. Masquerade and role-playing were very much in line with his view of life, and he had repeatedly expressed the view that humans had a specific role to play in the theatre of life. The numerous self-portraits as circus director, harlequin, carnival barker and in other costumes bear witness to this. In the famous *Double*

17 *Sinking of the Titanic*, 1912, oil on canvas
Saint Louis Art Museum, bequest of Morton D. May

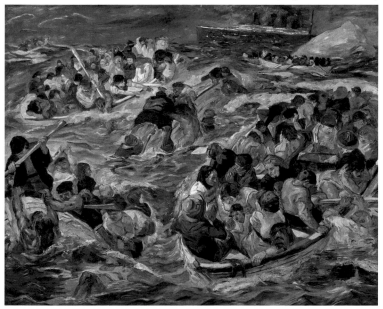

18 *'Look, I am Coming Soon …', Apocalypse,* 1941/42
Watercoloured lithograph, Private collection

19 *'Astrologer Speaks, Mephistopheles Blows'*, 1944, ink over pencil
Faust Drawing, sheet 10, 1st act, Freies Deutsches Hochstift,
Frankfurt am Main, State of Hessen and Federal Republic of Germany

20 *Double Portrait Carnival*, 1925
Oil on canvas
Museum
Kunstpalast,
Düsseldorf

Portrait Carnival (20), begun in spring 1925, the painter enters the stage with his young bride in costume.

The transformation that occurred in Beckmann's painting, in its expression, form and colouring, becomes evident in comparison with the double portrait with his first wife (21) of 1909. The young painter's almost arrogant self-assertion, with which he casually towers over the melancholy, almost mourning Minna, at the same time distancing himself from her and leaving a gap between them, has given way to a togetherness on equal

21 *Double Portrait of Max Beckmann and Minna Beckmann-Tube*,
1909, oil on canvas, Kunstmuseum Moritzburg, Halle

terms; even the hand gestures are synchronised. Now Beckmann follows the young Quappi out of the dark room behind the curtain. Nevertheless, a part of his being – as one half of his face symbolically shows – remains in the shadows. In one of the numerous love letters to his future wife, Beckmann draws a parallel between this double portrait and the depictions of Dante and Virgil.[14] If we take this view as a basis, Quappi leads Beckmann through hell to purification. Once again, Beckmann evoked his artistic ancestors, albeit here in an unusually cheerful and tongue-in-cheek manner.

SEEING AND OBSERVING

The Old Masters were decisive for Beckmann not only in their relationship to nature; he remained indebted to them formally and in his choice of genres. The series of self-portraits, the landscapes, figure paintings and still lifes, and later the triptychs, all bear striking witness to this.

Self-representation, the portrait and figure painting had top priority for Max Beckmann. The abundance of portraits he created in the course of his life is remarkable. All of them are based on a deep respect for the subject. No matter whom he portrayed, each sitter retained his or her dignity. Malice and caricatured exaggeration were alien to him. The painter was particular in observing people, even complete strangers, in detail and as if with 'X-ray eyes'. Although he constantly recorded his surroundings in drawings, he did not always find studies and sketches necessary for the genesis of the picture.

An impressive example of his portraiture is the *Portrait of an Argentinean* (22). The young South American, whom Beckmann saw in the Grand Hotel during his skiing holiday in St. Moritz, fascinated him with his quiet, almost aloof manner, which contrasted with the lively temperament of his compatriots travelling with him. Back in his temporary quarters in Paris, he painted the picture, which shows a cadaverously pale man, almost grotesquely made up to look 'alive', in front of black and blood-red depths – a doomed man. According to Günther Franke, who acquired the portrait, he later found out that the young man had taken his life shortly after this encounter. In his portrait, Beckmann anticipated the young man's impending tragedy in an almost visionary way. To be able to create such portraits,

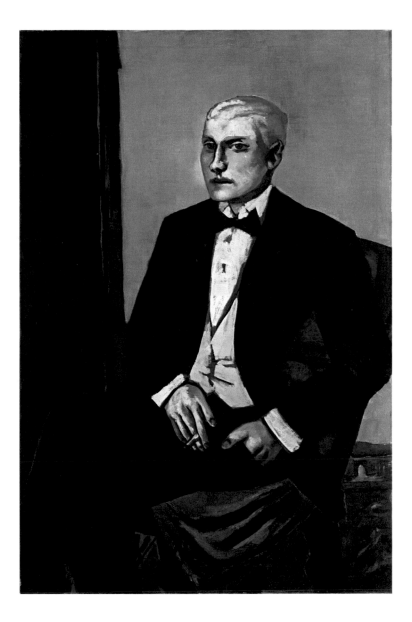

22 *Portrait of an Argentinæan*, 1929, oil on canvas
Pinakothek der Moderne, Munich

one needs a heightened interest in the world, a talent for picking up the vibrations from the subject like a seismograph, in order to then transfer them to a painting that reveals the traits, psyche and emotional mood of the sitter – but without exposing them.

SOURCES OF INSPIRATION

'Being a child of his time' meant for Beckmann not only the choice of his subjects, which had to reflect the real world, but also referred to the sources of his inspiration. The idea for a work was stimulated, triggered or influenced by various factors: cinema films or circus performances, observing patrons in a coffee house, an oversized champagne bottle as a remnant of a public relations campaign in a grotto near Valkenburg, a cigarette advertisement on the beach at Scheveningen, the signboard of an optician's shop or even reading a book.

The painter was an exceptionally intense reader with a wide range of interests. His library contained over 600 books and today forms part of his estate. The annotations and markings in many of these volumes reveal his intensive engagement with what he read. The library includes books on religious-philosophical questions of the cosmogenesis, as well as on Greek philosophy, the Kabbalah, astrophysics and Indian and European philosophy. Fairy tales or novels such as Bram Stoker's *Dracula* belonged to Beckmann's reading material, as did literature in many editions by Jean Paul, Friedrich Gottlieb Klopstock, Goethe and Gustave Flaubert. Flaubert's book *Temptation of Saint Anthony*, in an annotated edition of 1921 in his library, inspired him to paint the second of his ten triptychs, his work *Temptation* of 1936/37 (24).

The fact that Flaubert is not the only source, but that Beckmann made use of very different stimuli, can be seen, among other things, in the picture on the right in the triptych. A lift boy from the Kempinski Hotel in Berlin enters the scene, leading a half-naked, crawling woman by a bit and serving a crown on a tray. 'sometimes fate appears in the form of a lift boy'.[15] Thus Beckmann described the character of the figure, who can be the bearer of good or bad news. Immediately to the right below the boy, a shadow – the head of the painter himself, enlarged to monumental proportions – seems to assert its presence as a hidden self-portrait, a witness to the drama.

It is obvious that Max Beckmann never 'illustrated', even when explicitly depicting a literary subject such as Goethe's *Faust II*, for which he made 144 drawings. The painter created his own figures, his own pictorial language, his pictorial space, identified himself and his life situation with the protagonists.

When painting and graphic art were not enough for him, when they did not seem suitable, he resorted to pen and modelling clay (23). Three dramas, all created at the beginning of the 1920s and with good reason never performed during his lifetime, are just as much an expression of his creative will as the eight sculptures from the years 1934, 1936 and 1950. Beckmann was and always remained primarily a painter, seeing himself neither as a

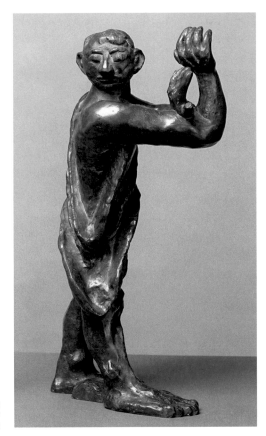

23 *Man in the Dark*, 1934
Bronze, Pinakothek der
Moderne, Munich

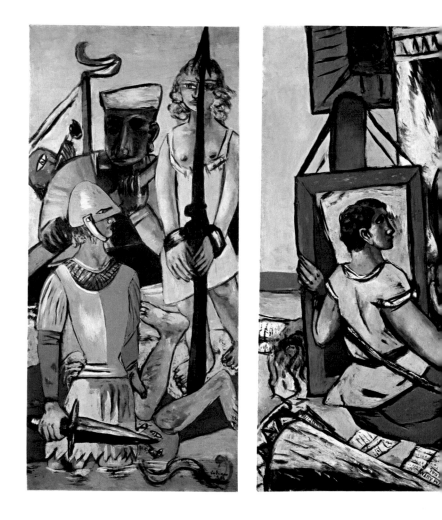

24 *Temptation*, triptych, 1936/37, oil on canvas
Pinakothek der Moderne, Munich

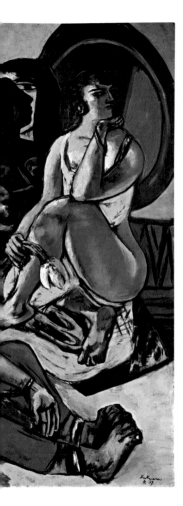
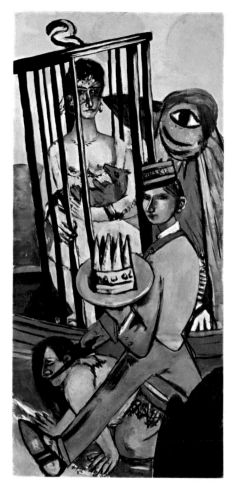

dramatist nor as a sculptor. Yet he chose these media quite consciously in order to work on his themes, the essential questions of human existence, almost like a private man, from another side, in another language.

Heinrich Simon once formulated how Max Beckmann created pictures from his world: 'In every single piece of the world he paints, he wants to show that a new world is growing. He plays the wonderful game of the human spirit, which always creates a new world out of the invariable material of trees, fields, stars, flowers, seasons, people, hate and love. But it is only truly new when what holds it together is new: the space. That which encloses it and the spirit that pervades it.'[16]

CHRISTIANE ZEILLER *wrote her dissertation on the early work of Max Beckmann and has participated in numerous exhibitions and publications. In 2010 she edited the catalogue raisonné of the sketchbooks. As a researcher at the Max Beckmann Archives she is currently cataloguing the estate of Max Beckmann, which was donated to the Bayerische Staatsgemäldesammlungen.*

1 From the recollections of Reinhard Piper, quoted in Reinhard Piper, *Mein Leben als Verleger. Vormittag. Nachmittag*, Munich/Zurich 1991, p. 330.
2 Heinrich Simon, 'Max Beckmann', in the series *Junge Kunst*, volume 56, Berlin/Leipzig 1930, p. 12 ff.
3 Ibid, p. 17.
4 *Max Beckmann. Briefe*, ed. by Klaus Gallwitz, Uwe M. Schneede and Stephan von Wiese with Barbara Golz, volume 1: 1899–1925, ed. by Uwe M. Schneede, Munich 1993, p. 178.
5 'Gedanken über zeitgemäße und unzeitgemäße Kunst, Erwiderung auf Franz Marcs Aufsatz "Die neue Malerei"', quoted in *Max Beckmann. Die Realität der Träume in den Bildern. Schriften und Gespräche 1911 bis 1950*, ed. Rudolf Pillep, Munich/Zurich 1990, pp. 12–15, here p. 15.
6 Foreword to the catalogue for the exhibition *Max Beckmann. Graphik* at J. B. Neumann, Berlin, November 1917, quoted in Pillep 1990 (see note 5), p. 20.
7 Max Beckmann: *Ein Bekenntnis. Beitrag zum Thema 'Schöpferische Konfession'* in the series *Tribüne der Kunst und Zeit* 1918, quoted in Pillep 1990 (see note 5), p. 20.
8 Pillep 1990 (see note 5), p. 37.
9 Speech for the friends and the philosophical faculty of the Washington University in St. Louis, given on 6 June 1950, quoted in Pillep 1990 (see note 5), p. 75
10 From the recollections of Reinhard Piper of a talk in 1919, quoted in Piper 1991 (see note 1), p. 331.
11 Unpublished letter from Günther Franke to Max Beckmann, 14 November 1950, Bayerische Staatsgemäldesammlungen, Max Beckmann Archives, Max Beckmann Estate.
12 Georg Hartmann to Max Beckmann, 31 December 1943, microfilm, Archives of American Art, Smithsonian Institution, Washington D.C.
13 From Beckmann's lecture 'Über meine Malerei', given on 21 July 1938 in the exhibition *Twentieth Century German Art*, London, New Burlington Galleries, quoted in Pillep 1990 (see note 5), p. 53.
14 Letter from 6 August 1925, in *Max Beckmann. Briefe I* 1993 (see note 4), p. 362.
15 In a talk with his son Peter Beckmann, most likely in 1937, quoted in Pillep 1990 (see note 5), p. 47.
16 Simon 1930 (see note 2), p. 18.

This essay is dedicated to the memory of Barbara Göpel (1922–2017). She was the co-author of the catalogue raisonné of the paintings of Max Beckmann – in many respects an exemplary work. The author and all those researching Beckmann and his work owe a lot to her.

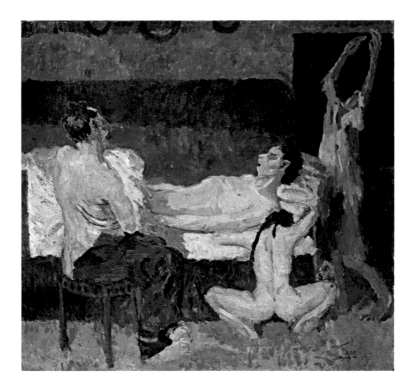

25 *Large Death Scene*, 1906, oil on canvas
Pinakothek der Moderne, Munich

MAX BECKMANN
LOCKS AWAY VITALITY

Bernhard Maaz

Beckmann's early paintings, such as the *Large Death Scene* (25) and the family portraits, already speak of melancholy. His experiences in the First World War were expressed in many oppressive works such as the *Self-Portrait with Stylus* (27) from the portfolio *Faces* of 1919, an image dominated by the empty gaze of gloomy eyes. The theme of deep mourning, the bitter experience of separation, the painful awareness of isolation and radical encapsulation culminates in works such as the monstrous Munich painting *Before the Masked Ball* from 1922 (26), in which – despite all the condensation – emptiness shines stridently through. Solitude within the community as a life experience has found here a startling, almost apocalyptic expressiveness. Where did this come from? The previous year, Max Beckmann described his own experience as an eight to ten-year-old in a letter to Reinhard Piper: 'At my sister's house [in Pomerania] I have my most intense memories of the loneliness of the great forests up there and the lakes and the midday heat of the white dusty tree-lined roads leading to the forest. You will probably have such images to. There is something strange about those youthful days. I was namelessly alone then.'[1]

In *Before the Masked Ball* he depicts his own son Peter at the left edge of the picture, reading, absorbed, shielded. No gaze is directed at him. This figure appears as a self-image of childhood par excellence on the part of the father, who in turn places himself under the lamp in the centre of the

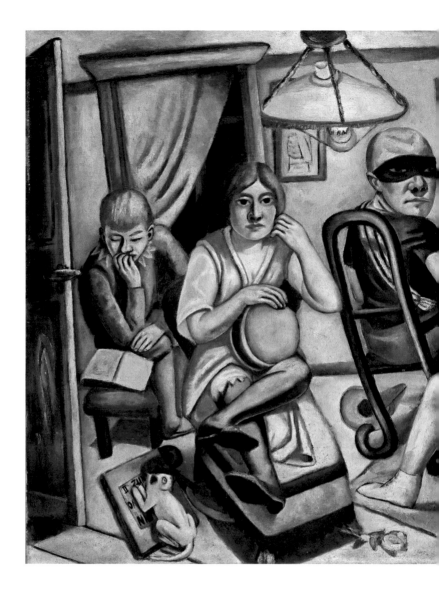

26 *Before the Masked Ball*, 1922, oil on canvas
Pinakothek der Moderne, Munich

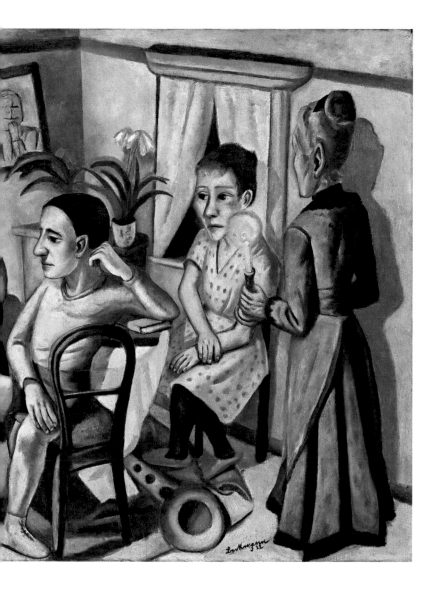

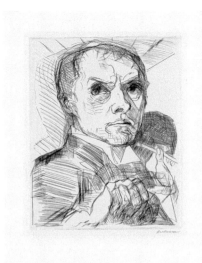

27 *Self-Portrait with Stylus*, 1919
Etching, drypoint
Sprengel Museum Hannover

picture and is masked without a glance. Inner solitude had become the artist's way of being, and he also projected it onto his surroundings.

The empathetic and stylistically confident Munich art critic Wilhelm Hausenstein addressed Beckmann's solitary relationship to the world from the perspective of his questionable integration into artistic movements and groups. He opened his essay laconically and monumentally: 'Let us refrain from classifying Beckmann in one of the contemporary categories! He is not an "Expressionist", nor does he have to deal with the galvanic arts with which the 'New Objectivity' attempts to conjure up the corpses of our epoch into an artificial life in artificial clarity'.[2] As Hausenstein further expounded, Beckmann 'painted the pictures alone in the most audacious sense of the word: unsociably, without assistance from any spirit of the group'.[3] And it is precisely in this sense that the painter presents himself in the *Masked Ball* as a lonely observer with a dead gaze and a mask in the midst of an expected – but not occurring – full life, as the centre of attention, but barricaded with regard to eye contact.

Beckmann portrays or shows people, and yet his letters are largely silent about his own emotions as well as theirs. He works with an almost traumatised self-denial and suppression of emotion. And in the 1924 letter to Israel Ber Neumann he says: 'I paint portraits still lifes landscapes visions

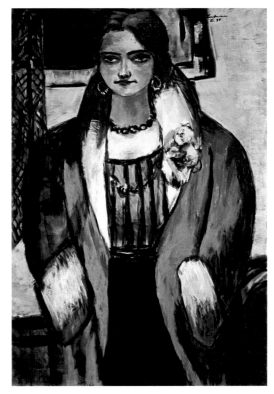

28 *Portrait of Naïla*, 1934
Oil on canvas
Private collection

of cities emerging from the sea, beautiful women and grotesque buffoons. Bathing people and female nudes. In short, simply life. A life that simply exists. Without thoughts or ideas.'[4]

Rarely does the face become 'reading material'. Often it remains – as in the Frankfurt double portrait of *Frau Swarzenski and Carola Netter* (29) – empty and mask-like. Only when Beckmann writes hymn-like poems to his young lover Mathilde Kaulbach, the famous Quappi, does the face become eloquent: 'The stars of your eyes stand in the radiance, like blue moons far away / The black forest sinks, the masks flee.'[5] And a little later he muses on the nature of people as he experiences them: 'My God, how lonely people all are among themselves.'[6] This double portrait thematises precisely this perception of the painter: two ladies are lonely together. Despite the almost oppressive physical closeness, there is no contact of eye

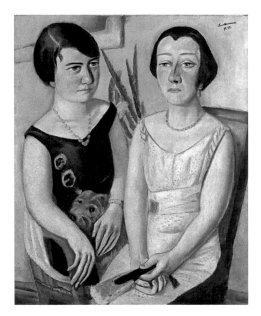

29 *Double Portrait of Frau Swarzenski and Carola Netter*, 1923, oil on canvas Städel Museum, Frankfurt am Main

nor gesture. Worse still, the gaze is empty despite the obvious chance of a full life; there is a consistent mental isolation as in a masked ball. Here, Beckmann redeems what he had postulated as a concept to Julius Meier-Graefe in 1919: 'The architecture of the pictures. Confining as great a sum of vitality as possible in crystal-clear lines and surfaces.'[7] And this does not just mean the composition of the picture, but reflects his emotional nature, from which he only broke out when he was passionately enraptured by, or with, his second wife Quappi.

The dialectic of vitality and coldness runs through Beckmann's life. A photograph from his estate shows the painter with the aforementioned beloved wife (30). He sits cloaked by multiple shieldings, namely protected by the buttoned-up shirt with tie, covered by the thick coat, shaded by the hat, shielded by the sunglasses. He looks like a secret agent; this sedate man resembles a bastion, is impregnable, monolithic. It is hard to imagine a denser silence than that proclaimed by this mouth. And there is a wave crashing: Quappi, the loving whirlwind, embraces the artist. She mischievously, provocatively, examines what is hidden behind his mask, under his hat brim, behind his glasses. Her unravelled curls swirl around the closed

face, her arms show symptomatic nakedness, she seeks to thaw the block of ice that nevertheless rejects the fullness of life. This motionlessness seems like the mirror of an inner paralysis. Vitality is imprisoned, the other person locked out – despite all the closeness. Wilhelm Hausenstein said that one could not help but 'gaze with emotion at the life of such a great male power' – by which he will have meant only Beckmann's Promethean creative power.[8] It is this that this photograph conveys, namely a delicate balance of empty gaze and vibrant life.

BERNHARD MAAZ *studied art history and archaeology. He was a researcher at the Berlin Nationalgalerie from 1986 and ultimately its vice-director. He is the author and editor of numerous publications and editions on the history of art and collections from the 15th century to today, and has curated international exhibitions on sculpture, painting and drawings, primarily from the 19th century. In 2010 he became the director of the Kupferstich-Kabinett and the Gemäldegalerie Alte Meister at the Staatliche Kunstsammlungen Dresden. Since April 2015 he has been General Director of the Bayerische Staatsgemälde-sammlungen, which also house the Max Beckmann Archives.*

1 *Max Beckmann. Briefe,* ed. by Klaus Gallwitz, Uwe M. Schneede and Stephan von Wiese with Barbara Golz, volume 1: 1899–1925, ed. by Uwe M. Schneede, Munich 1993, p. 197.
2 Wilhelm Hausenstein, *Meister und Werke,* Munich 1930, p. 257.
3 Ibid., p. 258.
4 *Max Beckmann. Briefe,* p. 254.
5 Manuscript poem by Max Beckmann, end of May 1925, Bayerische Staatsgemäldesammlungen, Max Beckmann Archives, Max Beckmann Estate.
6 *Max Beckmann. Briefe,* p. 301.
7 Ibid., p. 177.
8 Hausenstein, *Meister und Werke,* p. 258.

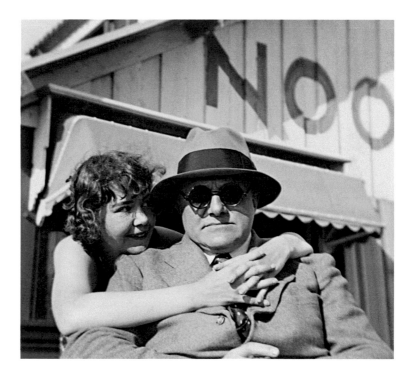

30 Max Beckmann and Mathilde 'Quappi' Beckmann in the Netherlands, probably Scheveningen, ca. 1928

BIOGRAPHY

Max Beckmann
1884–1950

1884 Max Beckmann is born in Leipzig on 12 February, the youngest of three children. His siblings Richard and Margarethe are ten and fifteen years older respectively. The father Carl Heinrich Christian Beckmann is a trader in grain, his mother Antoinette Henriette Bertha, née Düber, is from a family of farmers and millers.

1884–1894 Max Beckmann spends his early childhood in Leipzig, living between the ages of eight and ten with his married sister in Falkenburg in Pomerania. After his father dies in 1894, he moves with his mother to Braunschweig. His father's brother is appointed guardian.

1894–1899 Beckmann attends Dr Jahn's secondary school in Braunschweig, then a school in Königslutter. After difficulties at school he moves to a boarding school in Ahlshausen, which he leaves again after a short time. He paints an early self-portrait and fills his first sketchbooks.

1900 After discussions with his guardian, Beckmann obtains permission to attend the art academy to study painting. He does not pass the entrance examination at the Dresden Academy because, instead of copying a plaster cast of Venus as required, he submits his own pictures of Venus. After his work is examined at the Großherzogliche Kunstschule art school in Weimar, he is accepted into the Antiquity class.

1901–02 Beckmann switches to the nature class of the Norwegian portrait and landscape painter Carl Frithjof Smith. He will maintain a lifelong friendship with his fellow student Ugi Battenberg. At a carnival party in 1902 Beckmann meets his future wife Minna Tube, who has attended the art school since October.

1903 Beckmann and Minna Tube leave the Weimar art school at the end of the summer semester, after Beckmann is awarded the medal for painting. He travels to Paris, where he rents a studio and attends classes at the Académie Colarossi irregularly, but visits the Louvre all the more frequently. He admires Paul Cézanne in particular among the French masters.

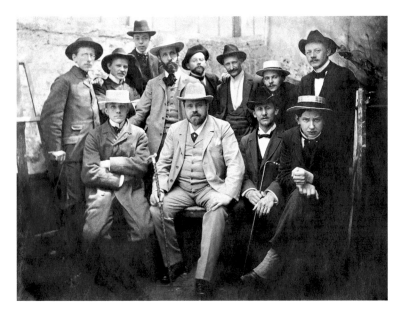

31 Max Beckmann (first row, seated, left) in the painting class of Carl Frithjof Smith, Großherzogliche Kunstschule Weimar, 1902

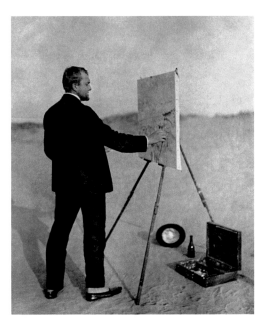

32 Max Beckmann painting at the Baltic, Vietzkerstrand, 1907

1904–05 Beckmann travels to Paris at the end of March and then hikes through Burgundy to Geneva. In April he returns to Berlin and, after spending the summer at the seaside, moves into a studio in the Schöneberg district. Beckmann begins to keep a record of his paintings. The years around 1904 seem to Beckmann to be the 'darkest and wildest time', as he notes in his diary on 11 January 1909.

1906 His painting *Young Men by the Sea* earns him an Honorary Prize from the Deutscher Künstlerbund (German Artists' Association) and a scholarship for a sojourn at the Villa Romana in Florence. The painting is purchased by the Grand Ducal Museum in Weimar. Beckmann takes part in the Berlin Secession exhibition. That summer he is shaken by the death of his mother, which is reflected in his work *Large Death Scene* (25). On 21 September Max Beckmann and Minna Tube marry in Berlin and travel to Paris for their honeymoon. On 1 November Beckmann begins his scholarship in Florence and spends the winter there with his wife.

1907 In spring the couple returns to Berlin and moves into a house designed by Minna in Hermsdorf. Beckmann spends the summer in Vietzkerstrand, a fishing village on the Baltic Sea. The exhibition 'Georg Minne - Max Beckmann' is held in Weimar and a joint exhibition with Ulrich Hübner takes place in Berlin at Paul Cassirer's gallery.

1908–09 Beckmann becomes a full member of the Berlin Secession. On 31 August his son Peter is born. Beckmann travels to Paris again. The art historian Julius Meier-Graefe visits him in his studio in Hermsdorf. Beckmann spends the early summer of 1909, as in the following year, on the North Sea island of Wangerooge. In Berlin he visits Emil Nolde in his studio. He devotes more time to his graphic works.

1910 Beckmann is elected to the board of the Berlin Secession as its youngest member. As the house in Hermsdorf is difficult to heat, the family moves into a studio flat at Nollendorfplatz in Berlin during the winter, until 1914.

1911 Max Beckmann resigns from the board of the Berlin Secession, but remains a member and takes part in exhibitions. He makes contact with

the art dealer and publisher Israel Ber (J. B.) Neumann, who publishes his prints, and with Max Sauerlandt, director of the museum in Halle, who acquires the *Double Portrait* (21).

1912 His first solo exhibitions are held at the Magdeburg Kunstverein and the Grand Ducal Museum in Weimar. In his response to Franz Marc's essay 'The New Painting' in the magazine *Pan*, Beckmann rejects the formalism of the Blauer Reiter group. He meets the publisher Reinhard Piper in Berlin and the Hamburg entrepreneur Henry B. Simms, who builds up the most extensive collection of Beckmann's paintings in the years prior to the First World War.

1913 On the occasion of the Beckmann exhibition in Berlin initiated by Paul Cassirer with 47 paintings, the first monograph on the 29-year-old artist is published, written by Hans Kaiser and published by Cassirer. Beckmann leaves the Berlin Secession after disputes with Ernst Barlach, Rudolf Grossmann, Max Pechstein and other painters.

1914 After the founding of the Free Secession in Berlin under the leadership of Max Liebermann, Beckmann is elected to the board. He is also an external member of the Munich New Secession. Beckmann regards the mobilisation for the First World War as a disaster. As he has no military training, he is able to avoid military service. He volunteers as a paramedic at the front in East Prussia.

1915–16 At the beginning of 1915 Beckmann goes to Belgium as a voluntary medical orderly; he makes numerous drawings. The war experiences trigger a physical and mental breakdown. Beckmann is given leave of absence from the medical service and goes to Frankfurt am Main in the autumn, where he is taken in by his student friend Ugi Battenberg. From August 1915 Beckmann is posted to Strasbourg as a draughtsman at the Imperial Institute for Hygiene, before returning permanently to Frankfurt. Beckmann only stays in Berlin occasionally. His wife begins her career as an opera singer.

1917–18 Beckmann is officially discharged from military service. J. B. Neumann organises an exhibition of 110 prints and about 100 drawings in his Graphisches Kabinett in Berlin. From 1918 on Beckmann begins

to occupy himself with the mystery cults of the Gnostics. His wife Minna takes up a position in Graz, where Beckmann frequently visits his family in the following years.

1919–20 An exhibition of Beckmann's new works at the bookshop Tiedemann & Uzielli in Frankfurt is reviewed positively in the press by Heinrich Simon and others. Beckmann declines an appointment as head of the nude drawing class at the Weimar art school. The lithograph series *Hell* is published by J. B. Neumann. Beckmann is a founding member of the Darmstadt Secession. From July until the beginning of 1920 he lives in the house of Heinrich Simon and his wife Irma in Frankfurt.

1921 Beckmann meets, among others, the art critic and writer Wilhelm Hausenstein in Munich and the art dealer Günther Franke in Berlin. In the early 1920s Beckmann writes plays, including *Ebbi* and *Das Hotel*.

1922–23 Beckmann makes over 90 etchings, woodcuts and lithographs, almost a third of his entire graphic oeuvre. He is represented at the 13th Venice Biennale with six prints. J. B. Neumann moves to New York and appoints Günther Franke as the manager of the Munich branch of his Graphisches Kabinett.

1924–25 In spring 1924 Max Beckmann meets Mathilde von Kaulbach ('Quappi'), daughter of the painter Friedrich August von Kaulbach, at the Motesiczky family's house in Vienna. The Beckmann monograph by Glaser, Meier-Graefe, Fraenger and Hausenstein is published by Piper. At the beginning of 1925, Beckmann is treated in a Viennese hospital after a fall in which he breaks his left hand; Mathilde von Kaulbach visits him frequently. Max Beckmann and Minna Tube-Beckmann divorce. In Paris Beckmann meets J. B. Neumann and concludes a contract with him for the sale of his paintings for a period of three years. Beckmann's works are presented in the Mannheim exhibition *New Objectivity*. On 1 September Max Beckmann and Mathilde von Kaulbach marry in Munich. Their honeymoon takes them to Rome, Naples and Viareggio. In October Beckmann is appointed by the municipal authorities of Frankfurt as head of a master's studio for five years at the School of Arts and Crafts, which has been merged with the Städelschule.

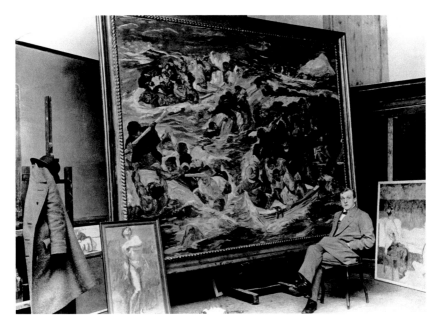

33 Max Beckmann in his studio in Hermsdorf in Berlin
in front of the painting *Sinking of the Titanic*, 1912

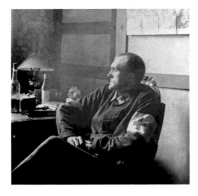

34 Max Beckmann as a volunteer
paramedic in Ypres, 1915

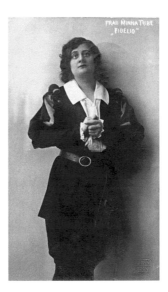

35 Minna Beckmann-Tube as
Fidelio in Elberfeld, 1916

1926–27 Beckmann's first solo exhibition in the United States takes place at J. B. Neumann's New Art Circle in New York. The art dealer Alfred Flechtheim is included in Beckmann's contract with J. B. Neumann. He visits Berlin, Paris and Spotorno on the Italian Riviera and goes skiing in Garmisch over Christmas.

1928 A comprehensive retrospective of Beckmann's work is held for the first time at the Mannheim Kunsthalle. Part of the very successful exhibition is subsequently shown at Flechtheim in Berlin and at Franke in Munich. The National Gallery in Berlin acquires *Self-Portrait in a Tuxedo* (9). Together with 15 other artists, including Ernst Ludwig Kirchner and Erich Heckel, Beckmann receives the 'Reichsehrenpreis Deutsche Kunst 1928'. In early summer he spends several weeks in Scheveningen, after which he creates a series of seascapes in his Frankfurt studio.

1929 Beckmann's painting *The Box* (8) is awarded a prize at the 28th International Exhibition of the Carnegie Institute in Pittsburgh. He receives the Grand Honorary Prize from the City of Frankfurt and rents a studio and a flat in Paris for the next three years. He lives there from September to May and travels to Frankfurt to the Städelschule for one week every month. He is officially appointed 'professor'.

1930 The Kunsthalle Basel and the Zurich Kunsthaus present extensive retrospectives. Beckmann is represented at the 17th Venice Biennale with six paintings. The Beckmann monograph by Heinrich Simon is published in the *Junge Kunst* series by Klinkhardt & Biermann. Beckmann's contract to teach at the Städelschule is extended until 1935. He works mainly in Paris until May as well as during the winter of 1930–31. His reading includes theosophy and Indian philosophy.

1931 Beckmann's first solo exhibition in Paris, presented at the Galerie de la Renaissance, is very well received, with Pablo Picasso and Ambroise Vollard among the visitors. Beckmann is represented with six paintings in the New York exhibition *German Painting and Sculpture* at the Museum of Modern Art. Various trips take Beckmann to Marseille, Saint-Cyr-sur-Mer, to the country estate of the von Kaulbach family in Ohlstadt in Upper Bavaria and to Vienna, Garmisch and Munich.

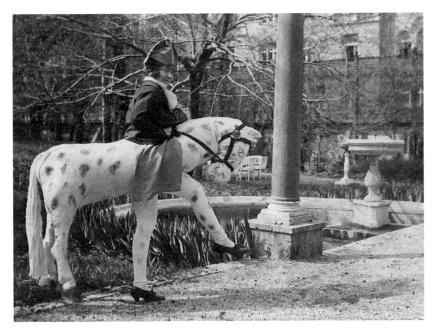

36 Quappi in a horse costume in the garden of the Kaulbach Villa during the wedding of her sister Hedda with Toni Stadler, Munich, May 1925

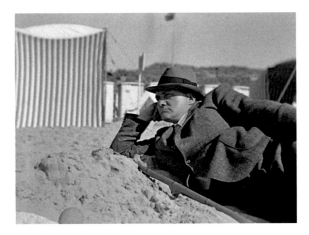

37 Max Beckmann on the beach, probably Scheveningen
No date, ca. 1925–1930

1932 The National Gallery in Berlin sets up a room with ten paintings by Beckmann in the former Kronprinzenpalais. He gives up his studio and flat in Paris. Beckmann is exposed to increasing attacks by the National Socialists in Frankfurt. At the end of the year he rents a flat in Berlin, where he sets up a room as his studio. Alfred Flechtheim cancels the contract with J. B. Neumann and Beckmann. Max Beckmann meets the art historian Erhard Göpel in Paris.

1933 In January the Beckmanns go to Berlin and move into a flat near the Tiergarten. After Hitler's rise to power in January, Beckmann is dismissed from the Städelschule on 31 March, with effect from 15 April. The Beckmann room in the National Gallery is closed. The opening of an exhibition planned for the Angermuseum in Erfurt is banned. The art collector and author Stephan Lackner sees the paintings in the museum's basement and acquires the first picture for what will later become an important collection of Beckmann's works.

1934-35 The first of a total of eight sculptures, *Man in the Dark* (23), is created. Beckmann's 50th birthday is hardly mentioned in the press, an exception being Erhard Göpel's article in the newspaper *Neue Leipziger Zeitung*. He takes part in a few group exhibitions in Germany and abroad, solo exhibitions of his works do not take place in these two years.

1936 Hildebrand Gurlitt presents paintings and watercolours by Beckmann in his Hamburg art cabinet, his last exhibition in Germany until 1946. Beckmann travels to Paris and meets Stephan Lackner, who lives there in exile. He and his wife consider emigrating to the United States.

1937 A total of 590 works by Beckmann are confiscated from German museums, including 28 paintings. Some of these works are shown in the Munich 'Degenerate Art' exhibition. On 17 July Beckmann and his wife emigrate to Amsterdam, to Quappi's sister Hedda, feigning the trip as a holiday; he will never set foot in Germany again. The Beckmanns manage to save the paintings left behind in the Berlin flat from confiscation and have them brought to Amsterdam together with their household goods. Beckmann rents a flat with a studio in the centre of the city. He creates lithographs for the drama by Stephan Lackner *Der Mensch ist kein Haustier*

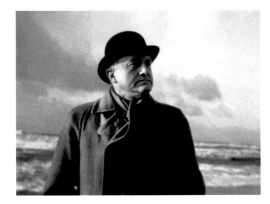

38 Max Beckmann in
Scheveningen, 1938

39 Max Beckmann in his
Amsterdam studio, 1938

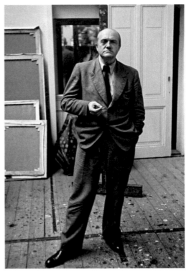

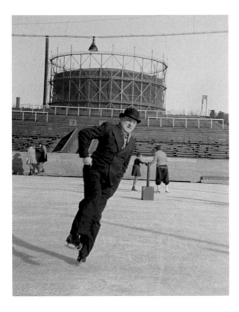

40 Max Beckmann ice-skating
in Amsterdam, 1941

(Humans Are Not Pets). Beckmann travels to Paris in September and spends the winter in Amsterdam.

1938 Curt Valentin shows works by Beckmann in his Buchholz Gallery in New York. On the occasion of the exhibition *Twentieth Century German Art*, Beckmann travels to London in July and gives the lecture 'My Theory of Painting'. His triptych *Temptation* (24) is shown there along with five other paintings. Together with Lackner he travels to the south of France. Lackner supports him financially with a guaranteed purchase of two paintings per month. From October to May/June 1939 Beckmann moves into a small flat in Paris, but keeps the Amsterdam flat.

1939 In April Beckmann travels to the Côte d'Azur. Until 1944 he paints about 15 landscapes and figure paintings based on impressions from his last stay on the Mediterranean before the outbreak of war. Beckmann receives a 'Carte d'Identité' residency permit and intends to give up the Amsterdam flat and move to Paris. In June, the triptych *Temptation* is awarded First Prize at the Golden Gate International Exposition in San Francisco. Shortly before the planned move, Beckmann decides to stay in Amsterdam because of the threat of war. The Second World War breaks out on 1 September.

1940 An offer from Chicago to give a two-month summer course at the Chicago Art Institute fails due to the denial of an entry visa for the United States. On 8 May, Lackner makes his last bank transfer to Beckmann. On 10 May, Holland is occupied by German troops. Beckmann and his wife burn their diaries.

1941 Correspondence with friends in the United States is cut off. Beckmann receives a commission from Georg Hartmann, owner of the Bauer'sche Schriftgießerei in Frankfurt, to illustrate the Apocalypse; a total of 27 lithographs are produced (18). Peter Beckmann visits his father in Amsterdam. As in the following years, he manages to take Beckmann's pictures to Germany and sell them. During the war years Beckmann's travels are limited to Holland, where he visits Zandvoort, The Hague, Hilversum and Valkenburg.

1942 Beckmann receives a draft notice, but is declared unfit for service. The Museum of Modern Art in New York acquires the triptych *Departure* through Curt Valentin.

1943 In February, Beckmann's paintings in the Amsterdam flat are in danger of being confiscated. Helmuth Lütjens, art dealer and representative of the Paul Cassirer Gallery in the Netherlands, takes these and subsequent paintings into his care. Beckmann is commissioned by Georg Hartmann to produce 144 drawings for Goethe's *Faust II* (19).

1944 Beckmann's health deteriorates; he suffers from pneumonia and heart problems. At the end of May he has to undergo a medical examination for military service again, but is declared unfit for service. After the Allied landing, the German occupation forces leave Holland. Communication with his German friends is severed.

1945 The periods of hardship and isolation weigh heavily on Beckmann; he temporarily lives in Lütjens' house, as he had done the year before. After the end of the war on 4 May, Beckmann fears he may be deported. In the autumn, some 14 of Beckmann's paintings are exhibited for the first time in Amsterdam's Stedelijk Museum. Contacts with friends in the United States, England and France are resumed. Since 'the last bed sheets [...] have been painted', Beckmann receives urgently needed canvas and paint, in addition to care packages.

1946 After years of an enforced hiatus, Beckmann produces his first graphic work, the portfolio *Day and Dream*, commissioned by Curt Valentin and created explicitly for the American market. A first exhibition of Beckmann's works in the United States after the war is organised by Curt Valentin at the Buchholz Gallery in New York and is warmly received by the press. Almost all the pictures shown there are sold. Günther Franke mounts the first Beckmann exhibition in Munich since 1936. Beckmann receives a call from Darmstadt to take over the direction of the art school there later known as the Werkkunstschule. However, he refuses this and all subsequent appointments to German universities. Beckmann is classified as a 'non-enemy' and the danger of expulsion from Holland is averted.

1947 In March Beckmann is finally able to travel again. He goes to Paris and spends three weeks in Nice with his wife. The Washington University Art School in St. Louis offers Beckmann a professorship, which Philip Guston has left vacant temporarily, that Beckmann accepts. On 29 August he embarks with his wife on a ship via Rotterdam to the United States; on board he meets Thomas and Katia Mann. Beckmann takes up his teaching post in St. Louis and instructs some 20 fourth-year students. During the critiques his wife is present as an interpreter. In November Beckmann travels to New York, where he meets J. B. Neumann, among others.

1948 Beckmann writes *Letters to a Painter*, a lecture text which is read at Stephens College in Columbia and at various universities in the following years. On 10 May, the most comprehensive Beckmann exhibition to date in the United States opens in St. Louis. It subsequently tours through several major museums in the United States, and Beckmann's work receives great attention and appreciation. His teaching position in St. Louis is extended until June 1949.

The Beckmanns travel to Boston, New York and Bloomington, Indiana, among other places, before they have to leave the United States on 5 June, as their residence permit has expired. They spend the summer in Amsterdam and return to the United States on 14 September after receiving their immigration visa. There they apply for American citizenship, but Max Beckmann will not live to see it come through. Beckmann's teaching position in St. Louis is extended until Guston's return in September 1950.

1949 Having been offered a professorship in painting and drawing by the Brooklyn Museum, Beckmann decides to move to New York in September. Morton D. May commissions his portrait from Beckmann and a friendly relationship develops between them. May begins to build up a collection of Beckmann's paintings. Travelling via Boulder, Colorado, where Beckmann holds a summer course at the university's art school, as well as Denver and Chicago, the Beckmanns arrive in New York on 30 August and move into a studio flat near Gramercy Park. At the end of September, Beckmann starts to teach at the Brooklyn Museum Art School. Beckmann wins First Prize for the painting *Fisherwomen* in the exhibition *Painting in the United States* at the Carnegie Institute in Pittsburgh.

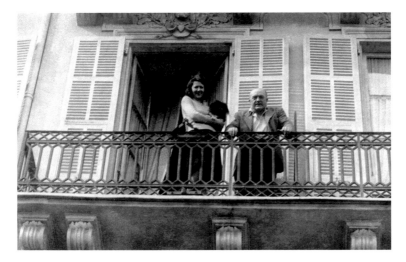

41 Quappi and Max Beckmann
on the balcony of the Hotel
Westminster, Nice, March 1947

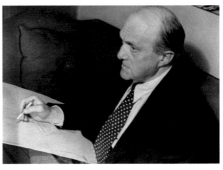

42 Max Beckmann drawing in
Saint Louis, 28 May 1949

43 Morton D. May and
Max Beckmann in May's
house in Saint Louis, 1949

1950 Beckmann's contract with the Brooklyn Museum Art School is extended until 1956. He is represented at the Venice Biennale with 14 paintings and receives the Conte Volpi Prize for Foreign Artists. In May, the Beckmanns move to a new flat in the immediate vicinity of Central Park. On 6 June Beckmann is awarded an honorary doctorate by the Faculty of Philosophy at Washington University St. Louis. Because of the Korean crisis, he abandons plans for a trip to Europe. On 26 December Beckmann finishes his work on the triptych *Argonauts*. On the way to the exhibition *American Painting Today* on 27 December, he collapses in the street and dies of a heart attack.

44 Max Beckmann in Central Park, New York, 1950

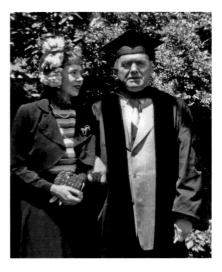

45 Receiving the honorary doctorate with Quappi, Washington University Saint Louis, 6 June 1950

46 Max Beckmann correcting a painting with Quappi and a student, Brooklyn Museum Art School, 1950

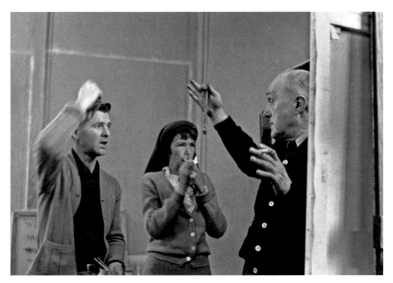

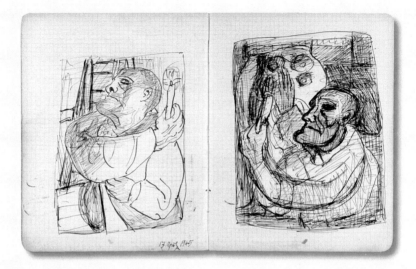

List of pictures *Heft II* (Notebook II), double page with two self-portraits, 1945, Bayerische Staatsgemäldesammlungen, Max Beckmann Archives, Max Beckmann Estate

ARCHIVE

Findings, Letters, Documents
1903–1948

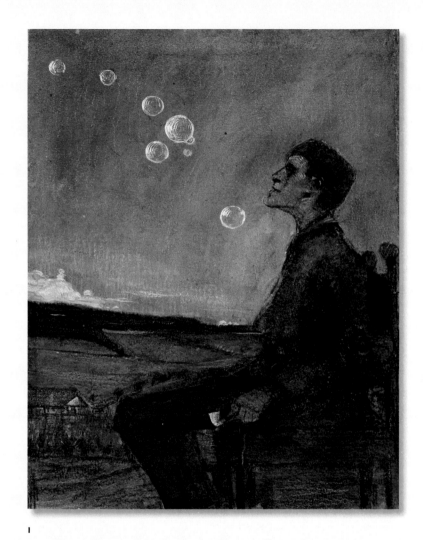

I

I *Self-Portrait with Bubbles*, ca. 1903, mixed technique
on cardboard, Private collection

Like many artists of his generation, Max Beckmann passed through the Jugendstil movement and experienced it during his years at the Großherzogliche Kunstschule in Weimar, primarily in the media of graphic arts. At the end of his training he made a self-portrait whose formal aspects, such as the composition of the head with its sharp edges and the atmosphere, still clearly speak the language of this style from the turn of the century. Appropriately, Beckmann chose these words while sharing his thoughts in a letter to the painter Caesar Kunwald, a fellow student from Weimar:

It is almost as if one sees happiness lying in the far distance, shimmering golden through blue expanses. [...] You also know that all the blue, the vastness, the veiled is the most beautiful and never the reality, the realised dream.

The posture of the head with the upturned chin and the depiction in profile symbolise at the same time the almost defiant self-assertion and the intensely perceived isolation of the young painter, who at the time of painting was moving into an uncertain future, like soap bubbles. The symbol of the soap bubbles, the distant gaze and, above all, an unsubstantiated longing and pensiveness, indicate Beckmann's proximity at this early stage to Romanticism.

2

Beckmann's manner of pictorial invention, of pictorial genesis, can be observed in one of the major works of the Frankfurt years, the painting The Synagogue *(4). In one of the preparatory sketches, Beckmann fixed the idea of bringing himself into the picture with his friends Ugi and Friedel Battenberg directly in front of the background of the synagogue, as people returning home from a carnival celebration. The pinholes in the drawing indicate that the painter worked with it in the studio and had it in front of him while painting, in addition to numerous on-site studies of the neighbouring buildings on Börneplatz in his sketchbooks.*
During the First World War, Beckmann had already tried like a man possessed to capture everything around him in drawings. He described the importance of

2

2 Sketch for *Synagogue*, 1919, Museum der bildenden Künste Leipzig, permanent loan from the estate of Mathilde Q. Beckmann
3 Black palette owed by Max Beckmann, Bayerische Staatsgemälde-sammlungen, Max Beckmann Archives, Max Beckmann Estate

3

the resulting abundance of detailed studies for his work in a field letter to his
first wife, Minna Beckmann-Tube, in April 1915:

Many of these realistic details will not serve me but gradually the atmos-
phere sinks into my blood and gives me confidence for pictures that I had
already seen in my mind's eye beforehand.

3

From the 1920s on the colour black became increasingly important in Beckmann's
painting. Never used as a pure pigment, but always mixed with other colours,
the painter employed it as an outline, blocking access as it were to his paintings
with it, in the form of grids, cut-off doors and other repoussoir elements. 'I too
am a black painter,' Erhard Göpel quotes Max Beckmann in his book Max
Beckmann. Reports of an Eyewitness, *and recalls:*

I asked Beckmann if he could not do without the black outline in a certain picture by working with pure colour contrasts. He looked at me reluctantly, almost crossly, from top to bottom – and such X-ray gazes had to be endured – with a look as if I had committed treason and betrayed him in favour of the late Matisse. You could see that the question would not let go of him. Then, after a 'You'll have to leave that to me', he added 'Yes, but don't you see that this is also colour?'

[...] Now there is no question that Beckmann, with the certainty of the great draughtsman that he was, pulled together many a picture that threatened to slip away from him by means of black contours; but until the end of the 1940s he possessed the power to transform black into colour.

4

After the years of privation in exile in Amsterdam, the hardship of the post-war years and life in a Europe that in many respects was in ruins, Beckmann experienced the new beginning in the United States like a salvation. He was touched by the positive energy of its youth, who had been completely spared war and misery and whom he now taught in St. Louis and later in New York. The comforts of modern big city life, from food to air conditioning, impressed him greatly, despite all his scepticism and reticence. In his diary he recorded on 18 September 1947:

It is possible that it will be possible to live here again.

In a letter to his first wife Minna, whom he always informed about his new life on the foreign continent in detail, he wrote in October 1947:

[...] a change of scenery was urgently needed and this is one – my goodness. You have no idea how different everything is here. But many things are amazingly good. So new that I am still completely amazed after three weeks here.

On 26 September 1948 he wrote in his diary about his work at the Brooklyn Museum Art School and its director Augustus Peck:

Yes, school. – To say it right away – pleasantly disappointed. Quite a lot of boys and girls, nearly 30 I think, and more to come. There were also some

quite acceptable girls and pleasantly grown-up boys. The whole atmosphere, also with Peck, very pleasant and critique only twice a week, – I didn't expect that at all. [...] In short, the subway and also the monitor [...] worked. – Quite swollen I made another subway tour to the Plaza this afternoon – and to my astonishment came out at Bloomingdale's. – At the Plaza very amusing guys etc. and satisfied with the Madison bus back in time for dinner. [...] In short, New York is doing well.

4 List of pictures *Heft II* (Notebook II), 1945, 1945, Bayerische Staatsgemäldesammlungen, Max Beckmann Archives, Max Beckmann Estate

SOURCES

—
PHOTO CREDITS

The illustrations were kindly provided by the
following museums, archives and collections:
Page numbers are indicated:

Artothek: 8
Artothek, photo: Ursula Edelmann: 21
Artothek, photo: Reinhard Hentze: 35
Artothek/Museum Kunstpalast: 34
Artothek/Städelmuseum: 13
Artothek/Städelmuseum, photo: U. Edelmann:
 14, 50
Hans Joachim Bartsch, Berlin: 27
Bayerische Staatsgemäldesammlungen –
 Sammlung Moderne Kunst in der Pinakothek
 der Moderne Munich: 18, 19, 23, 24, 25, 28, 37,
 39, 40/41, 44, 46/47, 52, © Jerk Michael
 Kunwald: 55 top, 55 bottom, © Oliver Baker:
 59 top, left, © Fotoatelier Saurin Sorani,
 Elberfeld: 59 bottom right, 61, 63 top, bottom,
 © Helga Fietz: 63 centre, 67 top, bottom,
 © J. Raymond: 67 centre, 69 top left, top right,
 © Paul Weller: 69 bottom, 70, 75, 77
bpk/Kunstsammlung Nordrhein-Westfalen,
 Düsseldorf, photo: Walter Klein: 16/17
bpk/Sprengel Museum Hannover,
 photo: Michael Herling/Aline Gwose: 48
bpk/Staatsgalerie Stuttgart: 20
Freies Deutsches Hochstift, Frankfurt am
 Main, State of Hessen and Federal Republic
 of Germany: 33
Grisebach GmbH, photo: Fotostudio Bartsch,
 Karen Bartsch, Berlin: 10
Kunsthaus Zürich: 28
Museum der bildenden Künste Leipzig: 74
St. Louis Art Museum: 30, 31
Van Abbemuseum, Eindhoven, the
 Netherlands, photo: Peter Cox: 12

—
THE FOLLOWING SOURCES
WERE USED FOR THE TEXT EXCERPTS:

Max Beckmann, letter to Caesar Kunwald,
17 April 1904, in: Max Beckmann. Briefe, ed. by
Klaus Gallwitz, Uwe M. Schneede and Stephan
von Wiese with the help of Barbara Golz,
volume 1: 1899–1925, ed. by Uwe M. Schneede,
Munich 1993, p. 22: 73

Max Beckmann, Letter to Minna Beckmann-
Tube, April 1915, in: Max Beckmann. Briefe, ed.
by Klaus Gallwitz, Uwe M. Schneede and
Stephan von Wiese with the help of Barbara
Golz, volume 1: 1899–1925, ed. by Uwe
M. Schneede, Munich 1993, p. 118: 75 top

Max Beckmann to Friedrich Vordemberge-
Gildewart, in Erhard Göpel, Max Beckmann.
Berichte eines Augenzeugen, ed. Barbara Göpel,
Frankfurt am Main 1984, p. 43: 75 bottom, 76 top

Max Beckmann, letter to Minna Beckmann-
Tube, October 1947, in: Max Beckmann. Briefe,
ed. by Klaus Gallwitz, Uwe M. Schneede and
Stephan von Wiese with the help of Barbara
Golz, volume 3: 1937–1950, ed. by Uwe
M. Schneede, Munich 1993, No. 835: 76 bottom

Published by
Hirmer Verlag GmbH
Bayerstraße 57–59
80335 Munich
Germany

Cover: *Self-Portrait in Tuxedo*, 1927, detail,
see p. 21
Double page 2/3: *Large Still Life with Telescope*,
1927, detail, see p. 18
Double page 4/5: *Before the Masked Ball*, 1922,
detail, see pp. 46/47

www.hirmerpublishers.com

ISBN 978-3-7774-4282-2

Printed in Germany

TRANSLATION
David Sánchez Cano, Madrid

—

COPY-EDITING
Jane Michael, Munich

—

PROJECT MANAGEMENT
Rainer Arnold

—

GRAPHIC DESIGN
Marion Blomeyer, Rainald Schwarz, Munich

—

LAYOUT AND PRODUCTION
Hannes Halder

—

PRE-PRESS AND REPRO
Reproline mediateam GmbH, Munich

—

PRINTING AND BINDING
Grafisches Centrum Cuno GmbH & Co. KG, Calbe

This publication was produced in cooperation
with Bayerische Staatsgemäldesammlungen.

BAYERISCHE
STAATSGEMÄLDESAMMLUNGEN

Bibliographic information published by the
Deutsche Nationalbiliothek. The Deutsche
Nationalbibliothek lists this publication in the
Deutsche Nationalbibliografie; detailed
bibliographic data is available on the Internet
at http://dnb.de.

THE GREAT MASTERS OF ART SERIES

ALREADY PUBLISHED

MAX BECKMANN
978-3-7774-4282-2

HEINRICH CAMPENDONK
978-3-7774-4084-2

PAUL CÉZANNE
978-3-7774-3813-9

WILLEM DE KOONING
978-3-7774-3073-7

LYONEL FEININGER
978-3-7774-2974-8

CONRAD FELIXMÜLLER
978-3-7774-3824-5

PAUL GAUGUIN
978-3-7774-2854-3

RICHARD GERSTL
978-3-7774-2622-8

JOHANNES ITTEN
978-3-7774-3172-7

FRIDA KAHLO
978-3-7774-4138-2

VASILY KANDINSKY
978-3-7774-2759-1

ERNST LUDWIG KIRCHNER
978-3-7774-2958-8

GUSTAV KLIMT
978-3-7774-3979-2

KÄTHE KOLLWITZ
978-3-7774-4137-5

HENRI MATISSE
978-3-7774-2848-2

PAULA MODERSOHN-BECKER
978-3-7774-3489-6

LÁSZLÓ MOHOLY-NAGY
978-3-7774-3403-2

KOLOMAN MOSER
978-3-7774-3072-0

ALFONS MUCHA
978-3-7774-3488-9

EMIL NOLDE
978-3-7774-2774-4

AGNES PELTON
978-3-7774-3929-7

PABLO PICASSO
978-3-7774-2757-7

HANS PURRMANN
978-3-7774-3679-1

EGON SCHIELE
978-3-7774-2852-9

FLORINE STETTHEIMER
978-3-7774-3632-6

VINCENT VAN GOGH
978-3-7774-2758-4

MARIANNE VON WEREFKIN
978-3-7774-3306-6

www.hirmerpublishers.com